Color Me Miserable

A Coloring Book
for the
Cranky Colorist

Racehorse Publishing

Racehorse Publishing books may be purchased in bulk at special discounts for sales promotion, corporate gifts, fund-raising, or educational purposes. Special editions can also be created to specifications. For details, contact the Special Sales Department, Skyhorse Publishing, 307 West 36th Street, 11th Floor, New York, NY 10018 or info@skyhorsepublishing.com.

Racehorse Publishing™ is a pending trademark of Skyhorse Publishing, Inc.®, a Delaware corporation.

Visit our website at www.skyhorsepublishing.com.

10 9 8 7 6 5 4 3 2 1

Cover design by Michael Short
Interior artwork: Shutterstock/OlichO

Print ISBN: 978-1-63158-162-5

Printed in the United States of America

INTRODUCTION

Coloring is a meditative exercise that relieves stress and, for an hour or two, encourages you to forget all of your problems. Recall the hours you spent as a child with your beloved crayons and markers, creating masterpieces from nothing but the whims of your imagination, and by subtly ignoring the problems that caused your parents to pull out their hair. Now, chances are you—you big grown-up, you—have little time to do things like color. You're out in the world, busy doing adult things like getting into college, shopping for groceries, buying TVs you can't afford, going out to dinner, accruing debt.

As adults, we often forget that we, too, can still enjoy such distractions like coloring. Proven to be beneficial for brain development and maturation, coloring is a healthy and productive way to de-stress. While the act itself is beneficial, what you choose to color is also important. Pretending sadness doesn't exist and that there are no problems in the world by coloring some flowers? Not great. But embracing the cycle of utter hopelessness? Well, that's a Buddhist concept! Move over, mandalas!

Take a moment from your busy day and enjoy not only wallowing in your misery, but decorating it with pretty colors! The graceful lines and creative motifs in the following thirty-eight designs are fun and easy to color (let's be real, you're not an artist), while the rather blunt words and phrases appeal to that inner pessimist screaming inside your head. Whether you're standing in the three-hour line at the DMV saying, "Is this it? Is this really it?" or you're cleaning your cat's litter box as it watches from afar, smug and emitting a small, backhanded "meow," these designs will help you express the thoughts you so often keep pent up inside.

So, grab some colored pencils, find a quiet place or put on headphones with some relaxing music, and embrace life's turmoil. You'll feel much better once you do.

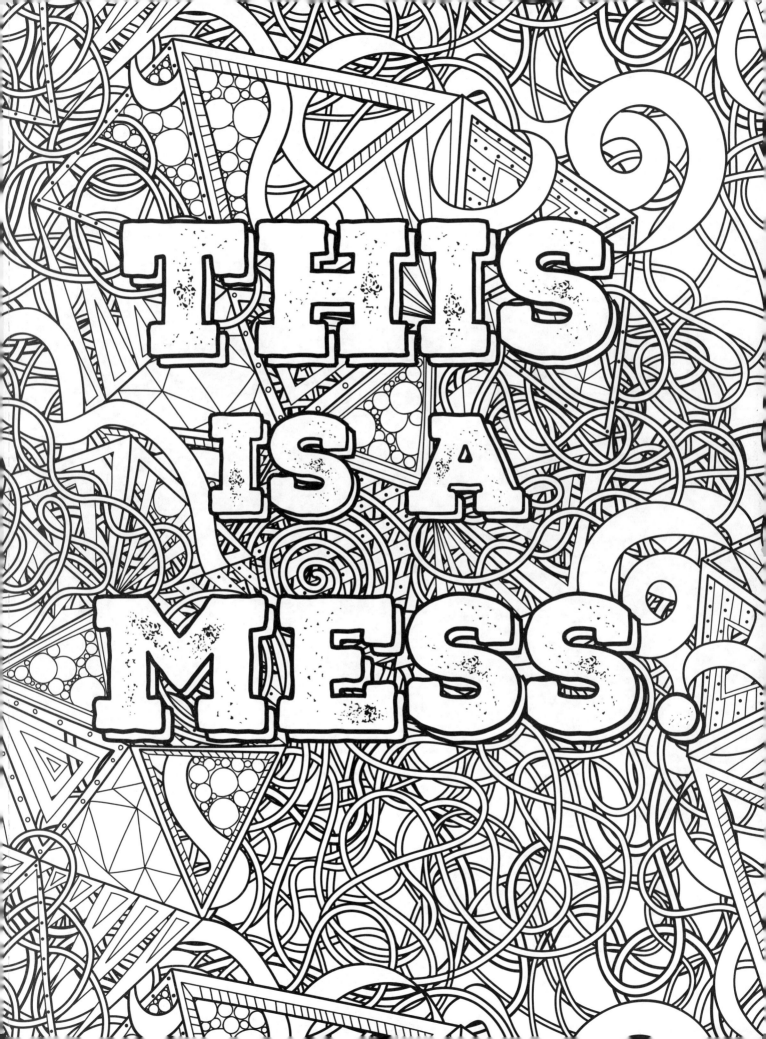

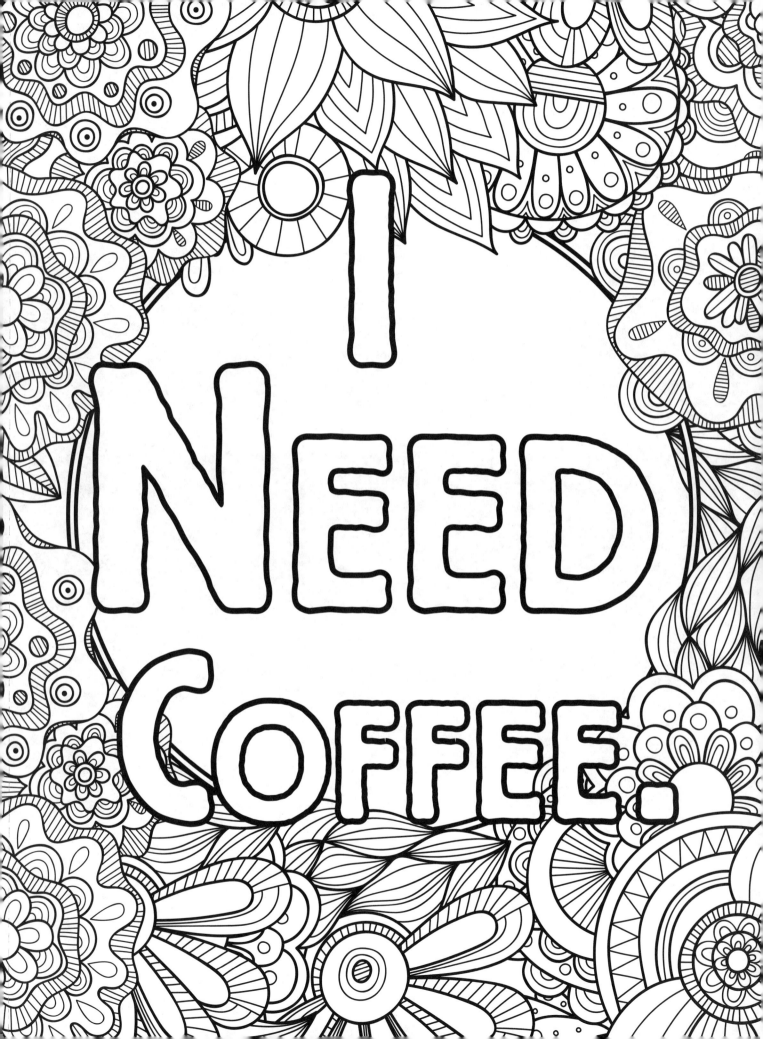

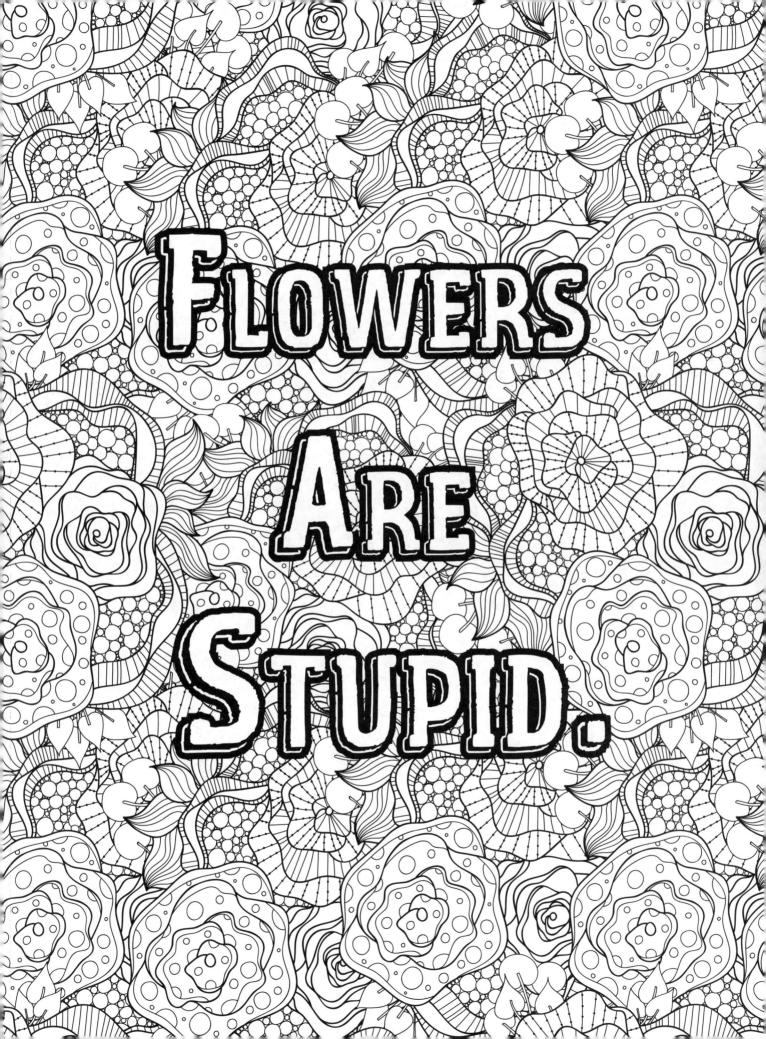

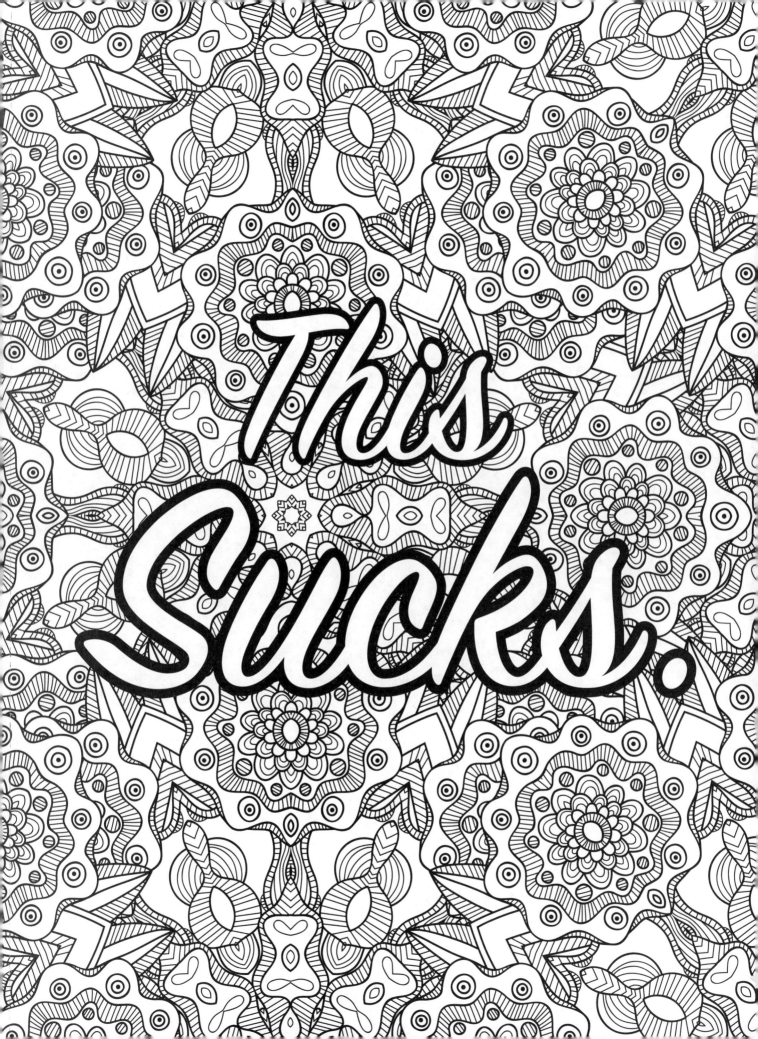

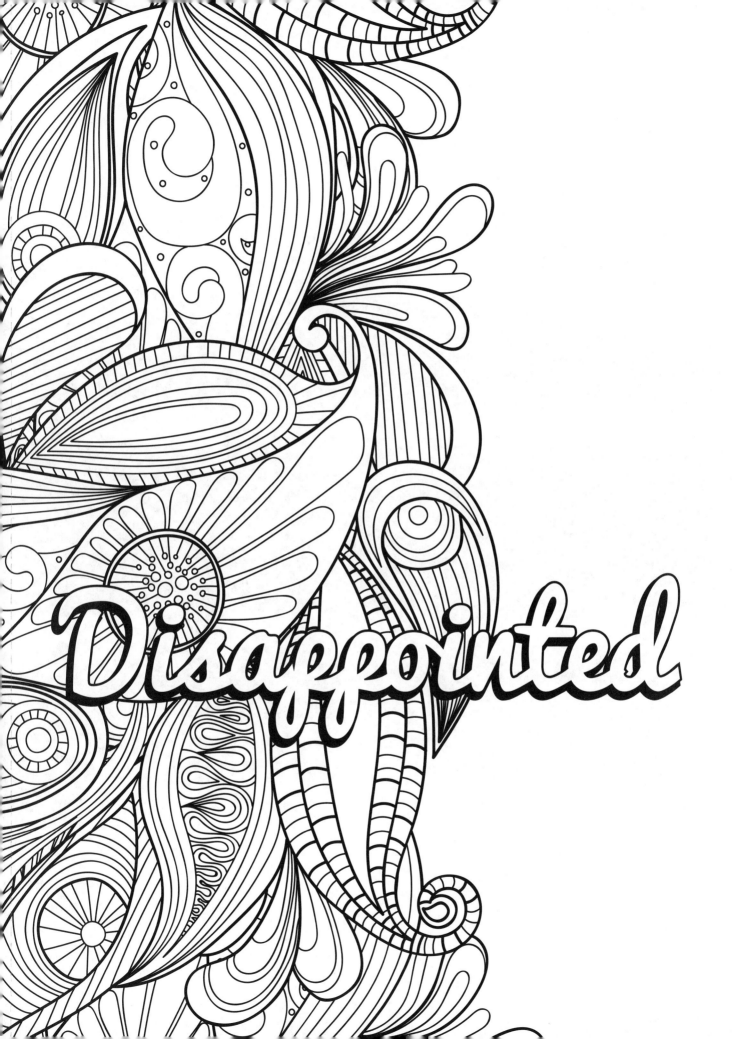

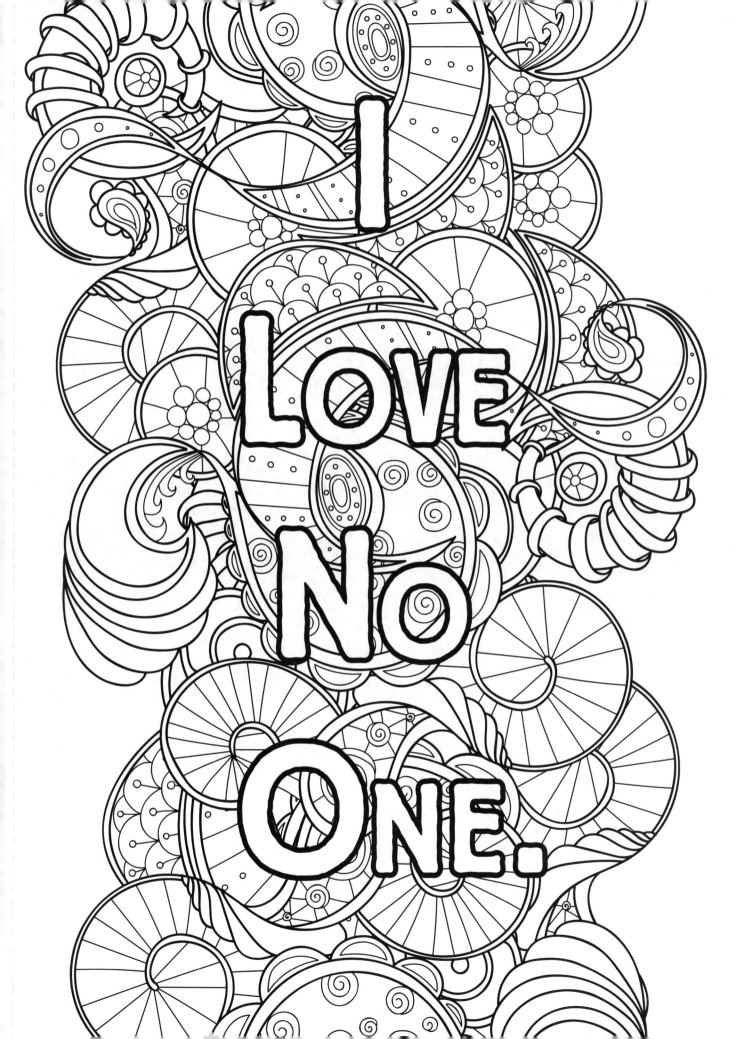

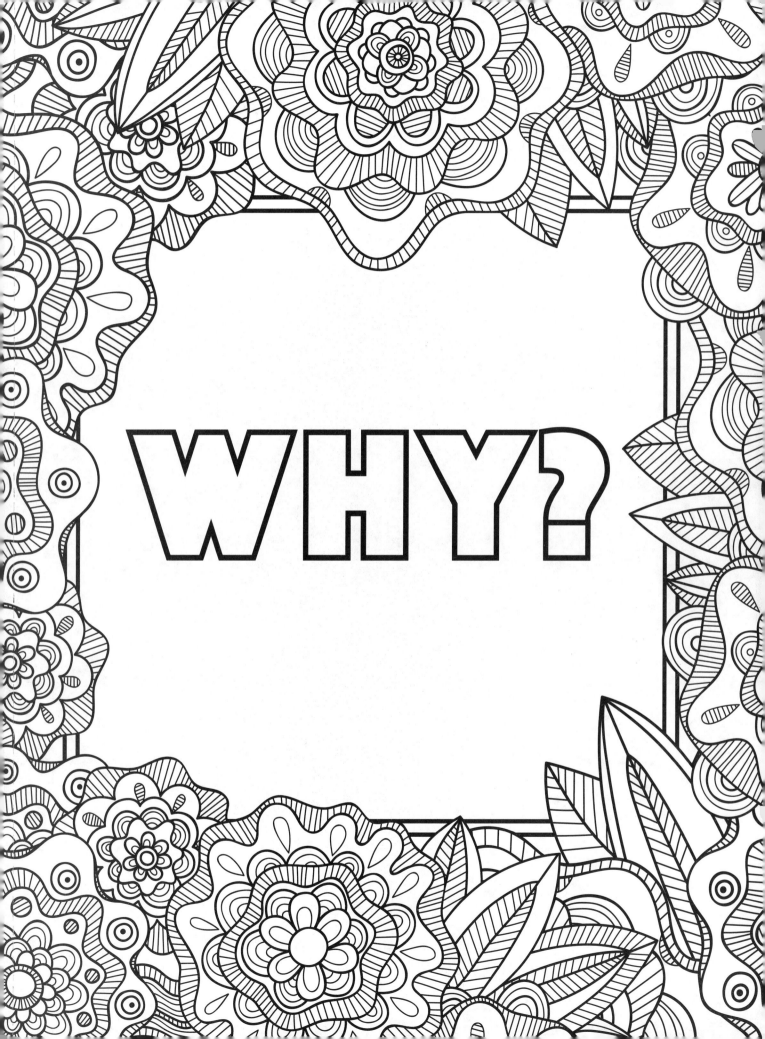

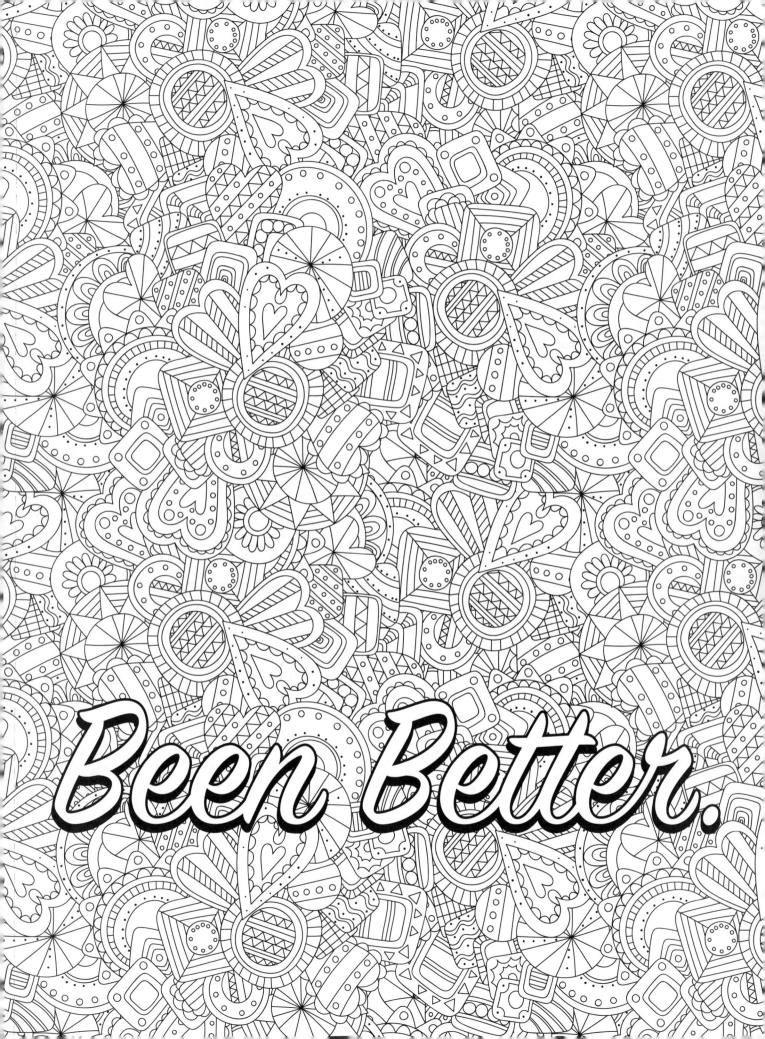

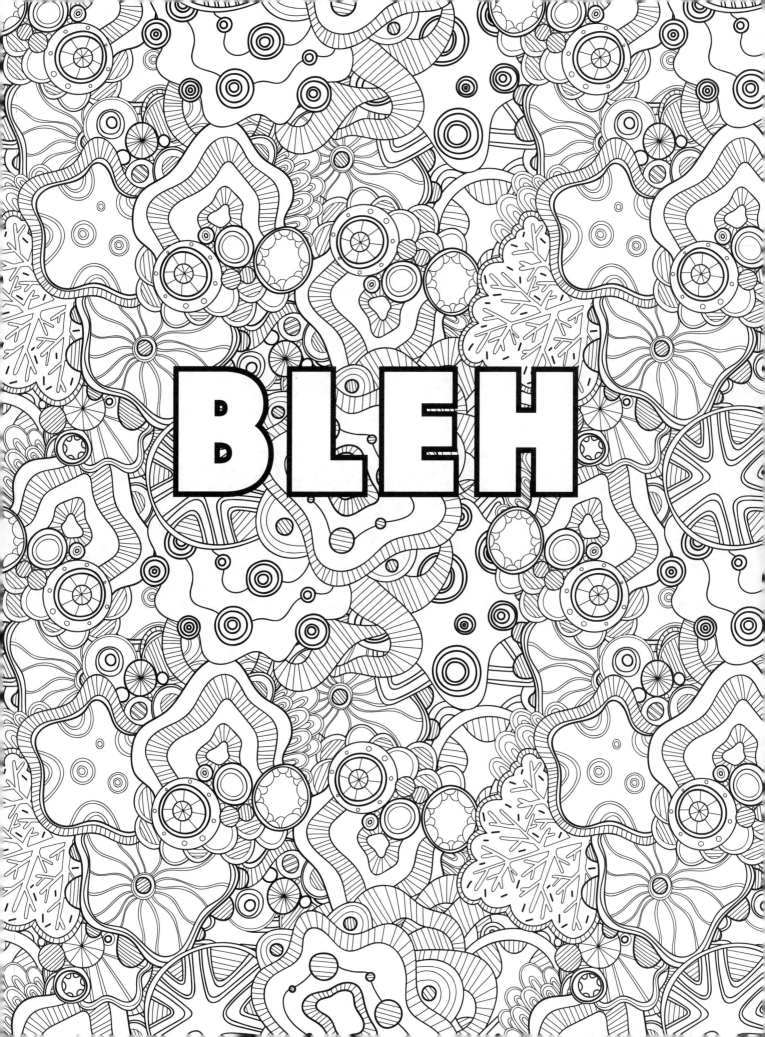

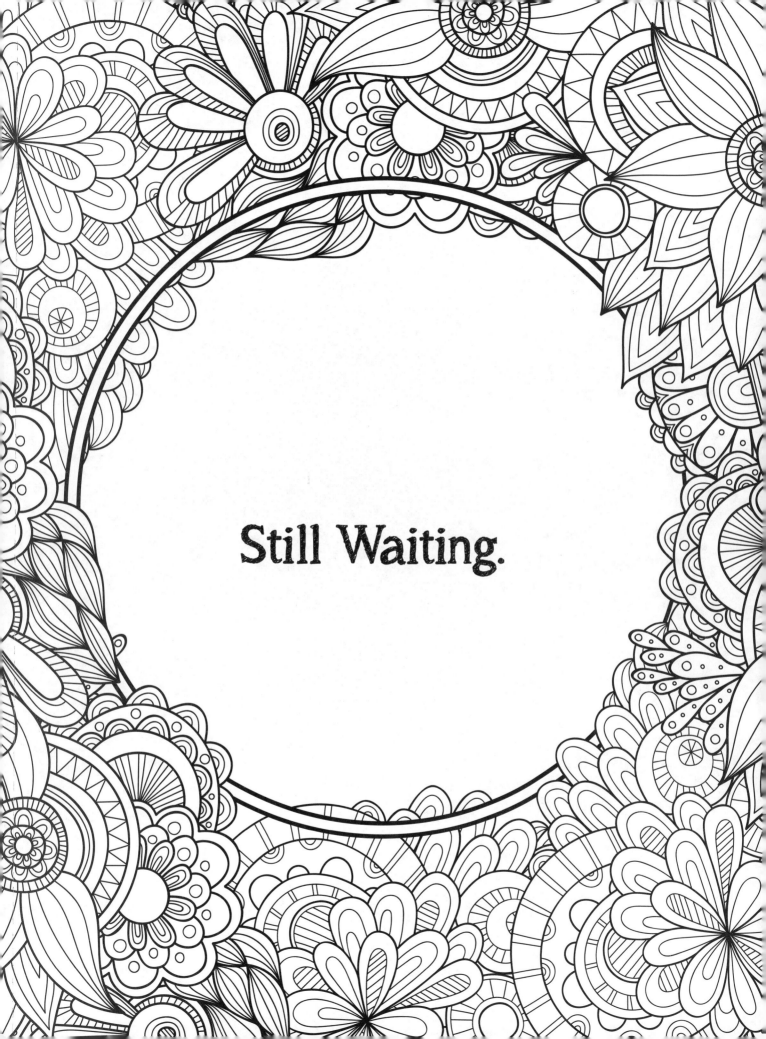

Still Waiting.

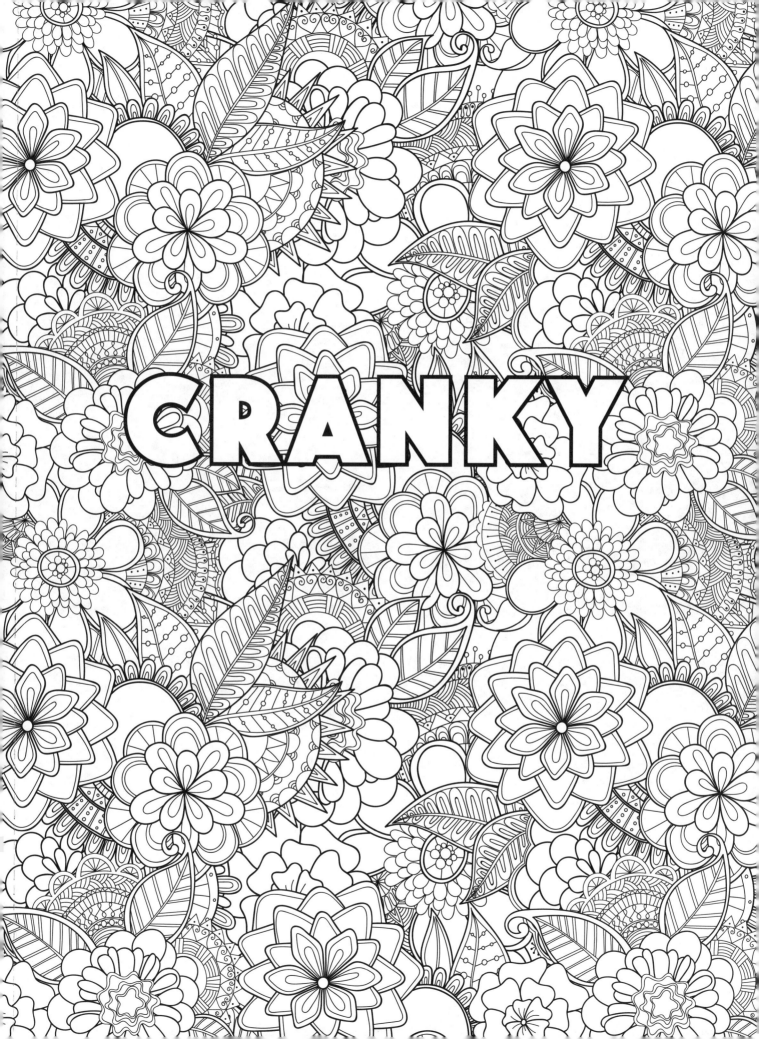

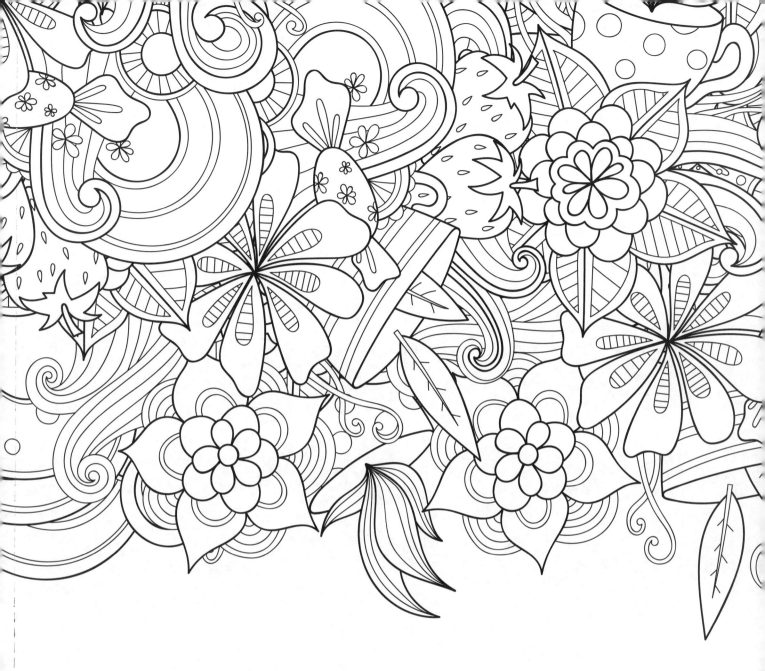

Can't even.

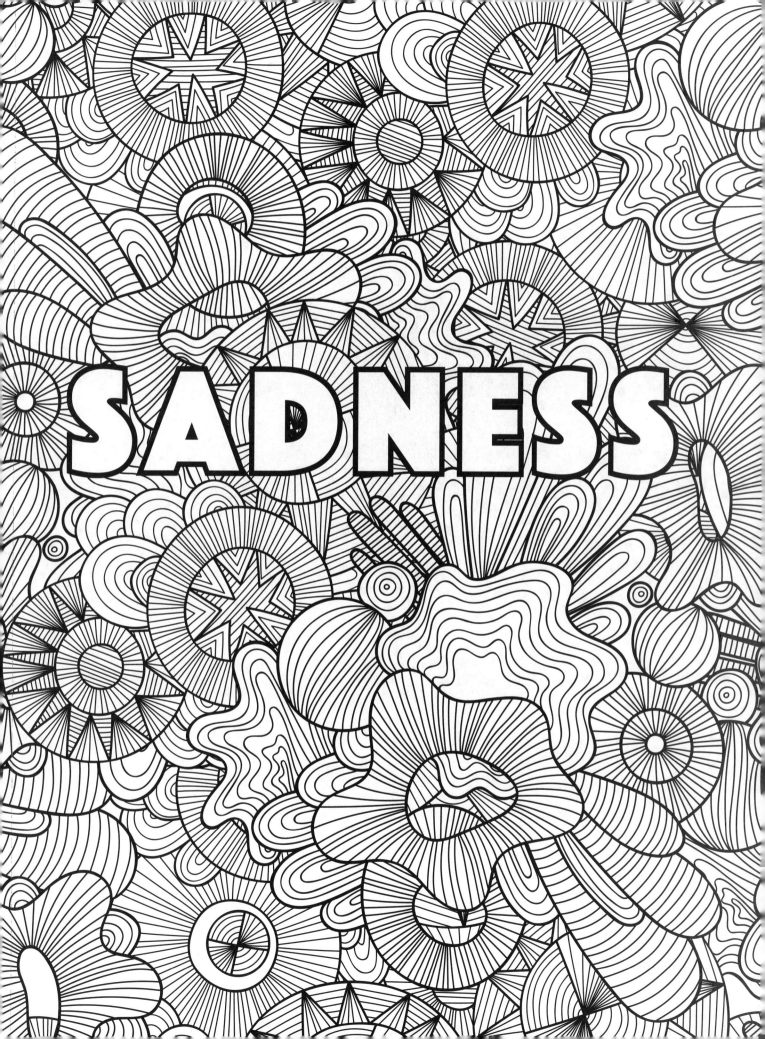

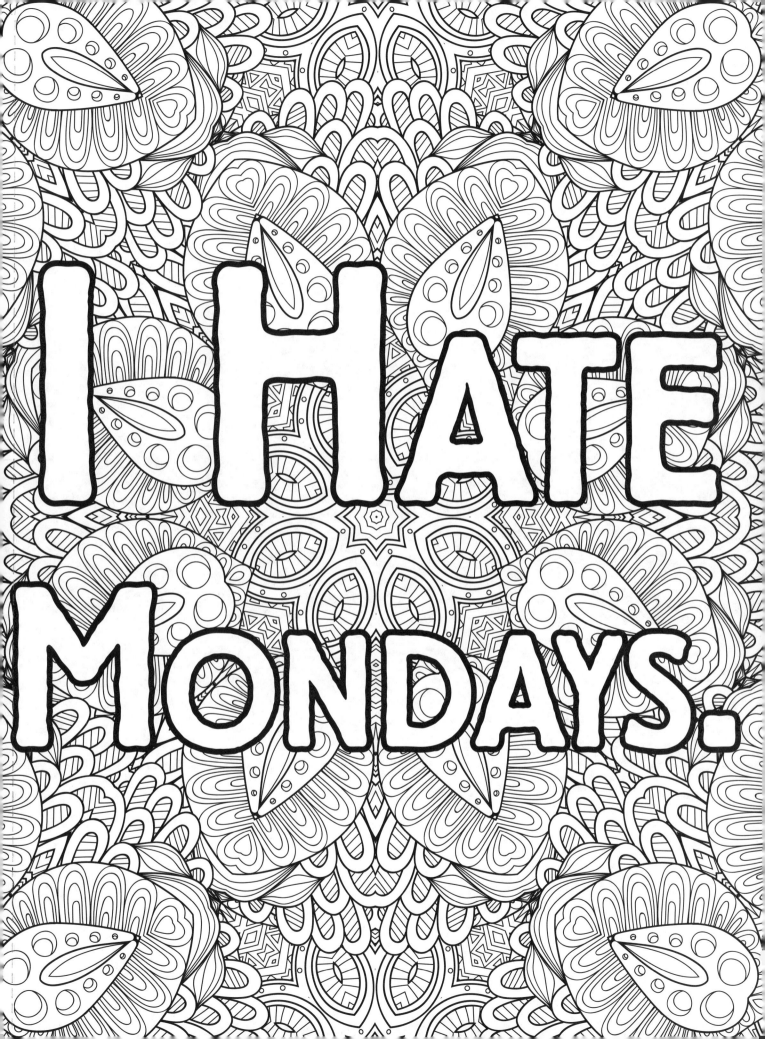

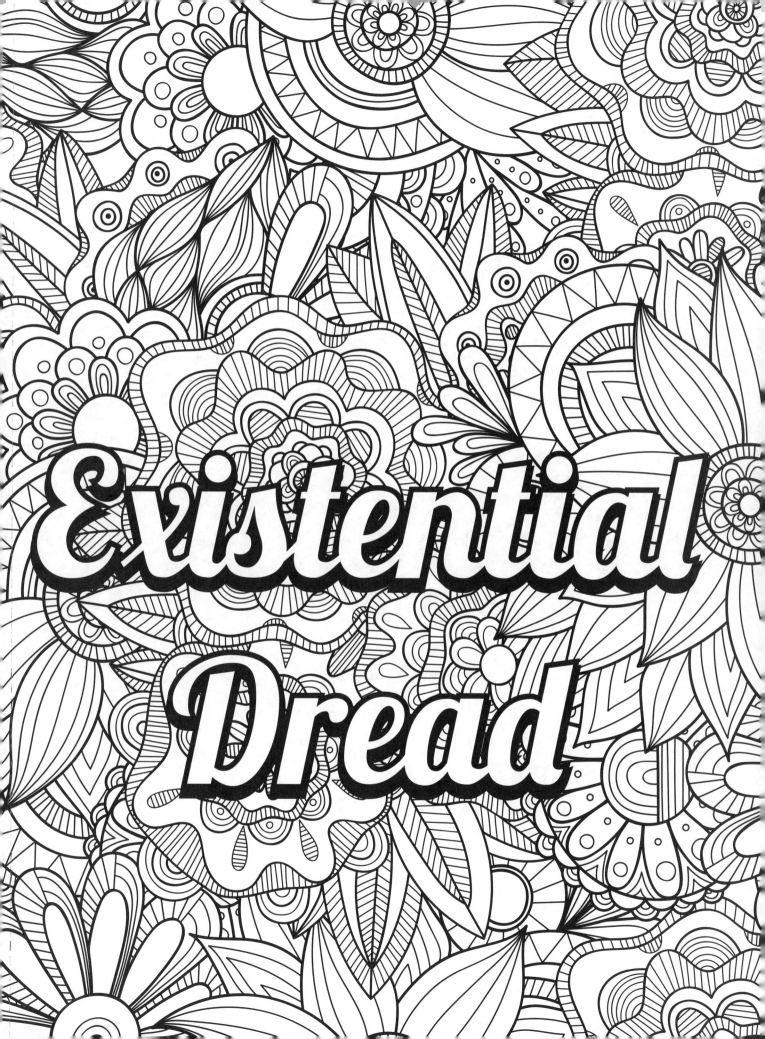

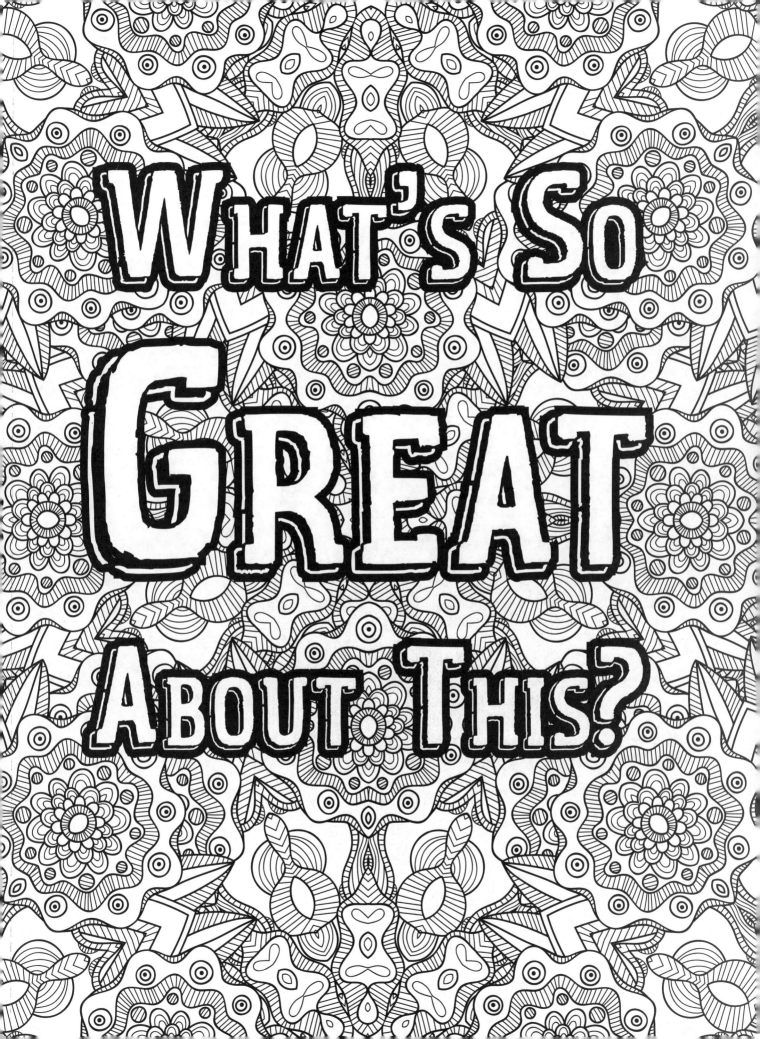

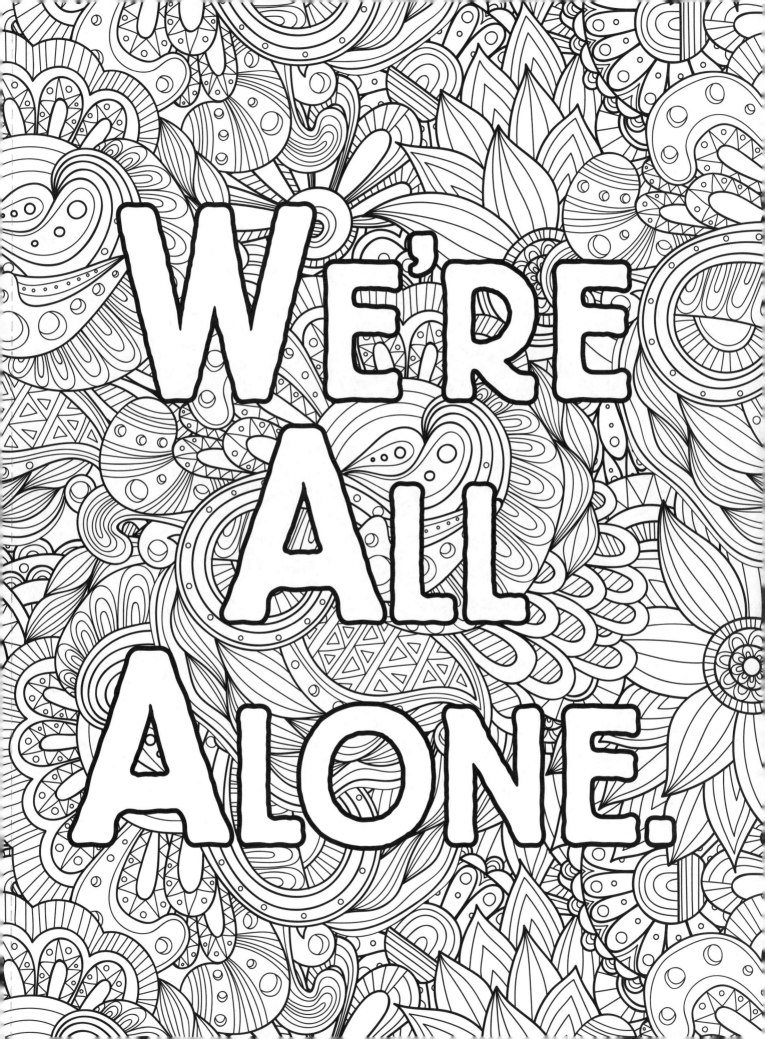

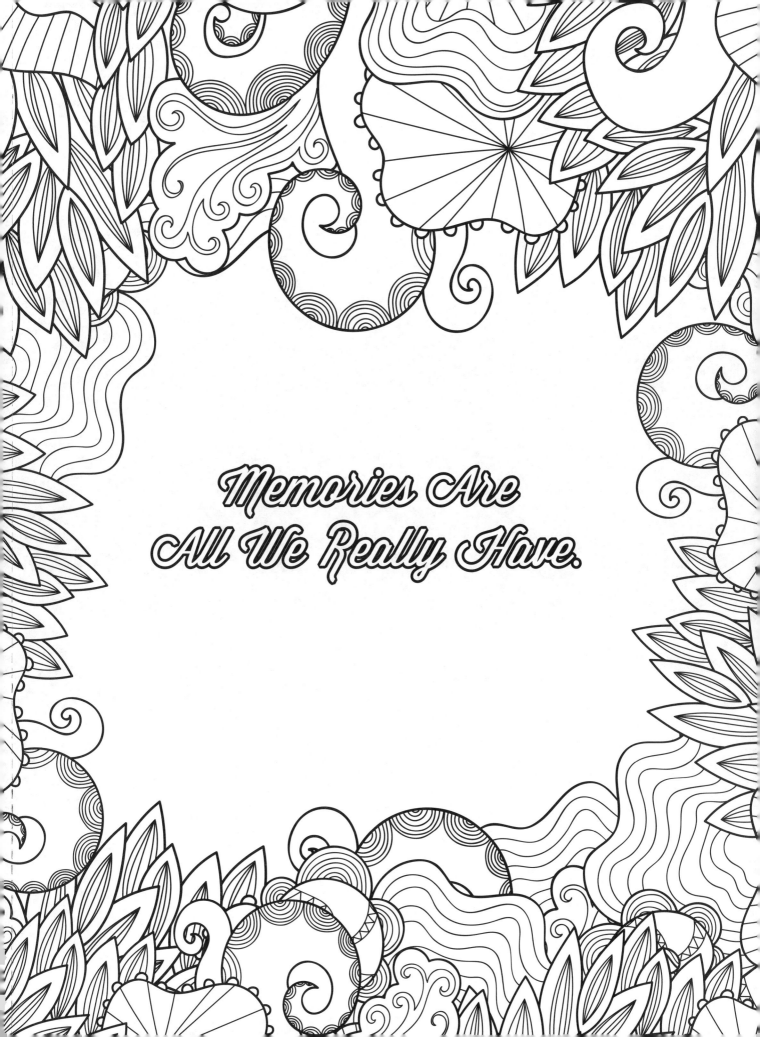

Memories Are
All We Really Have.

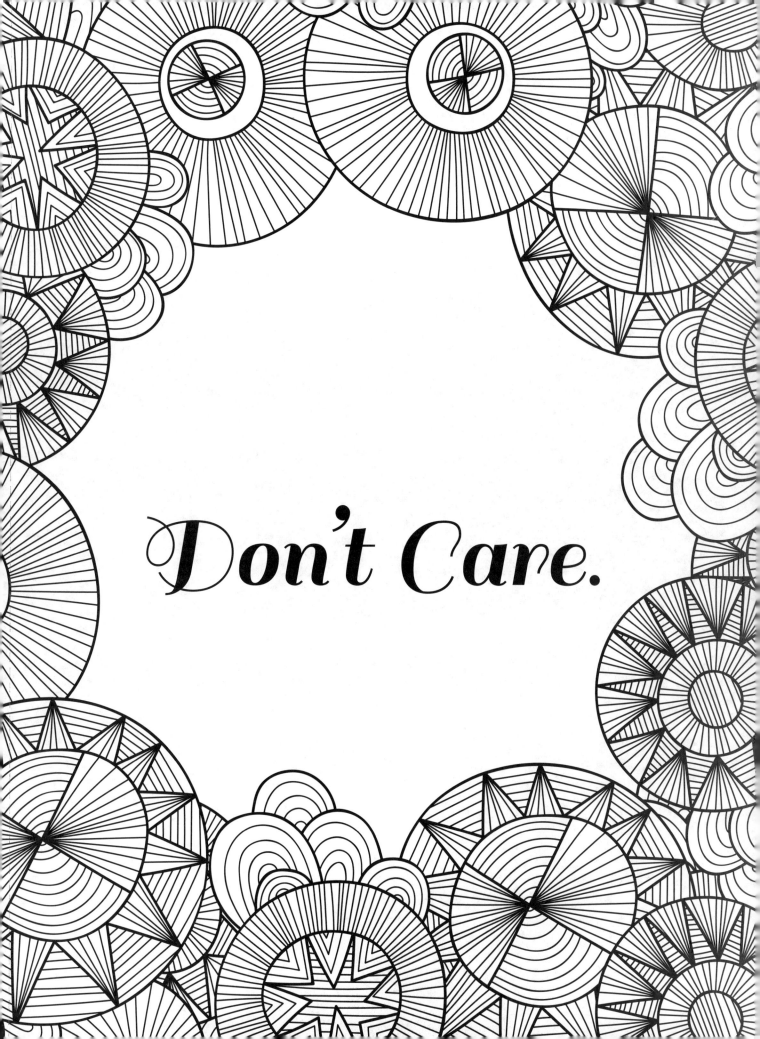

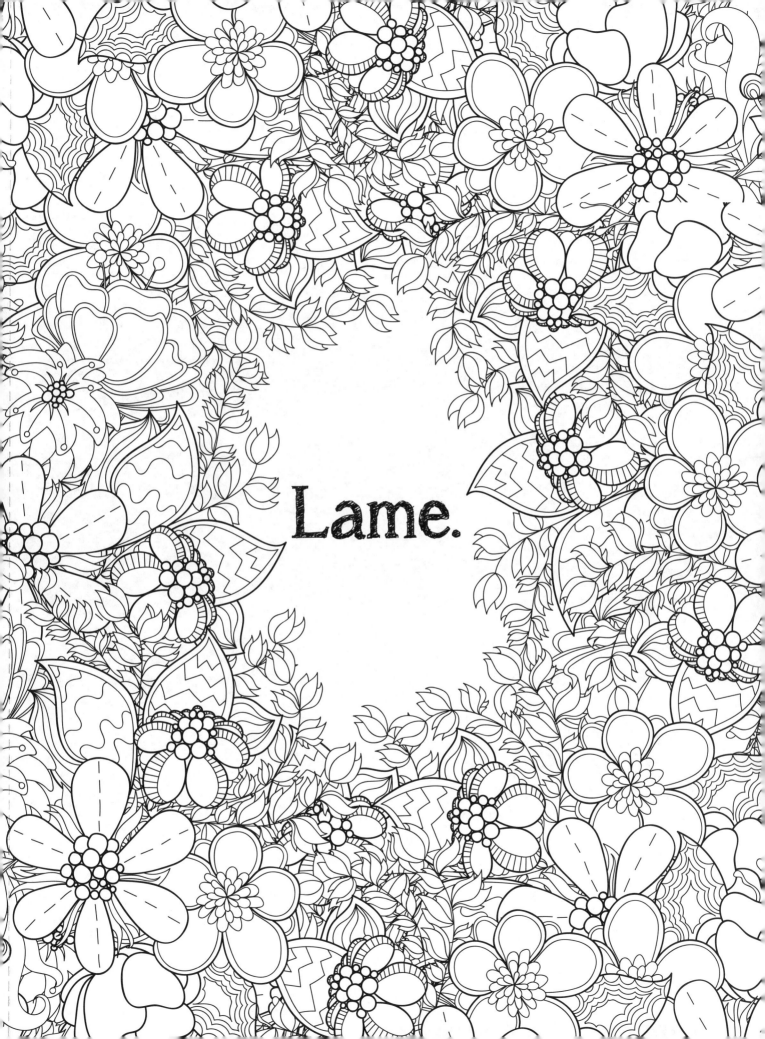

Lame.

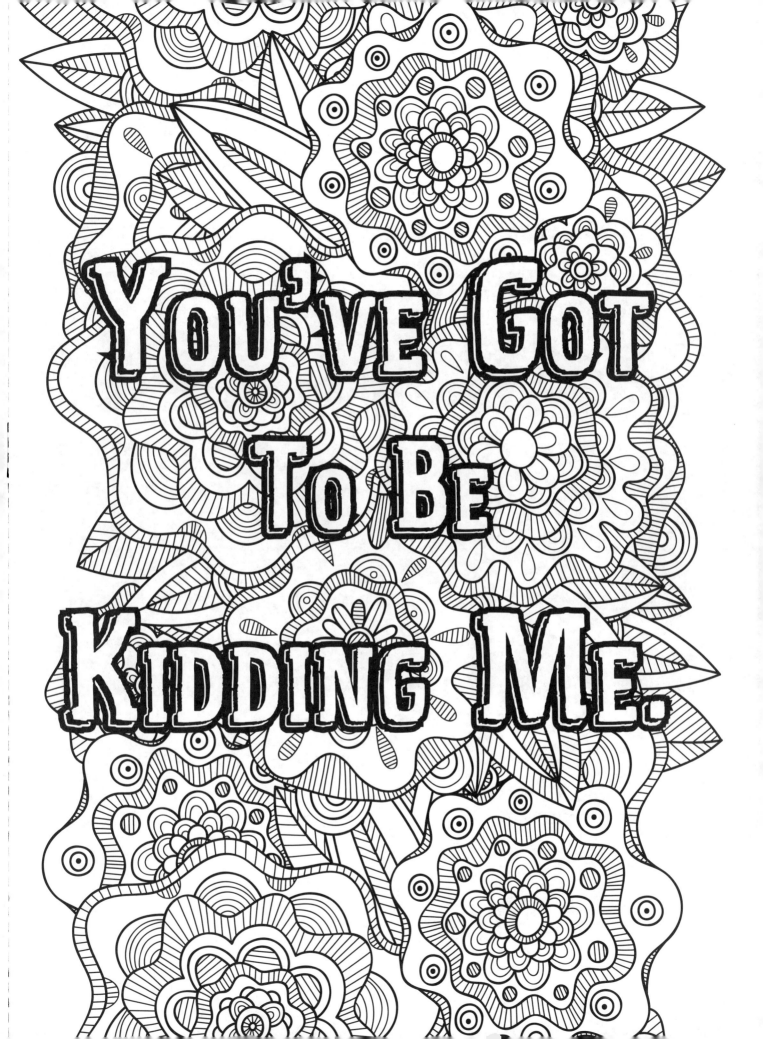

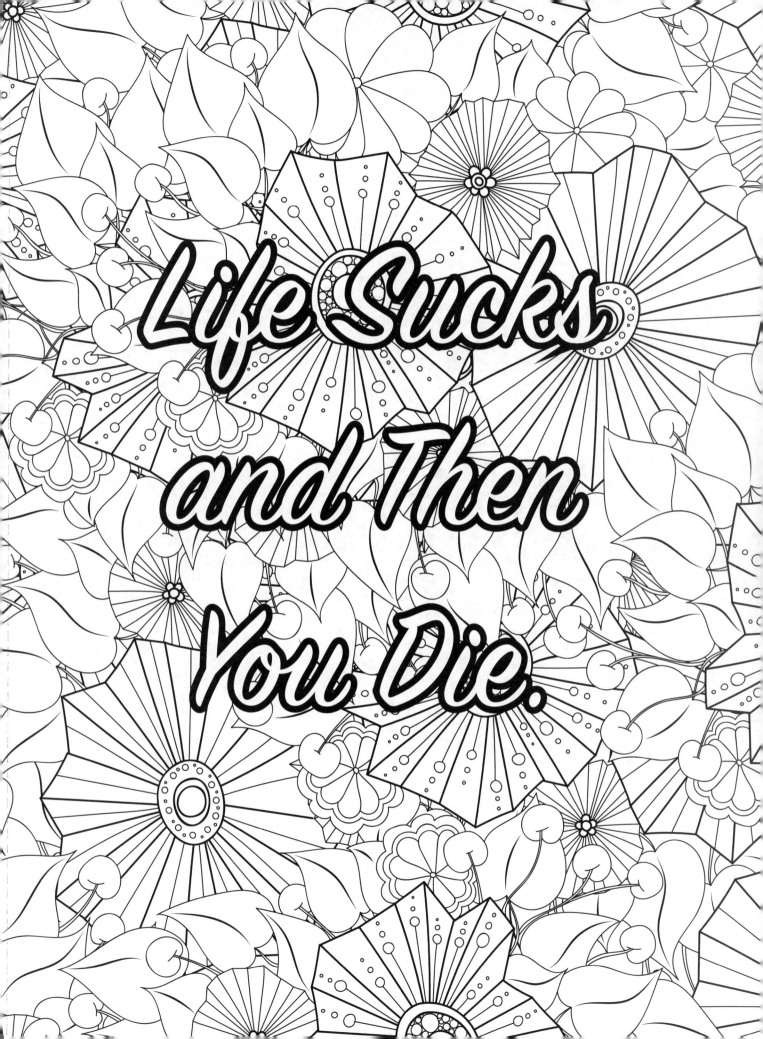

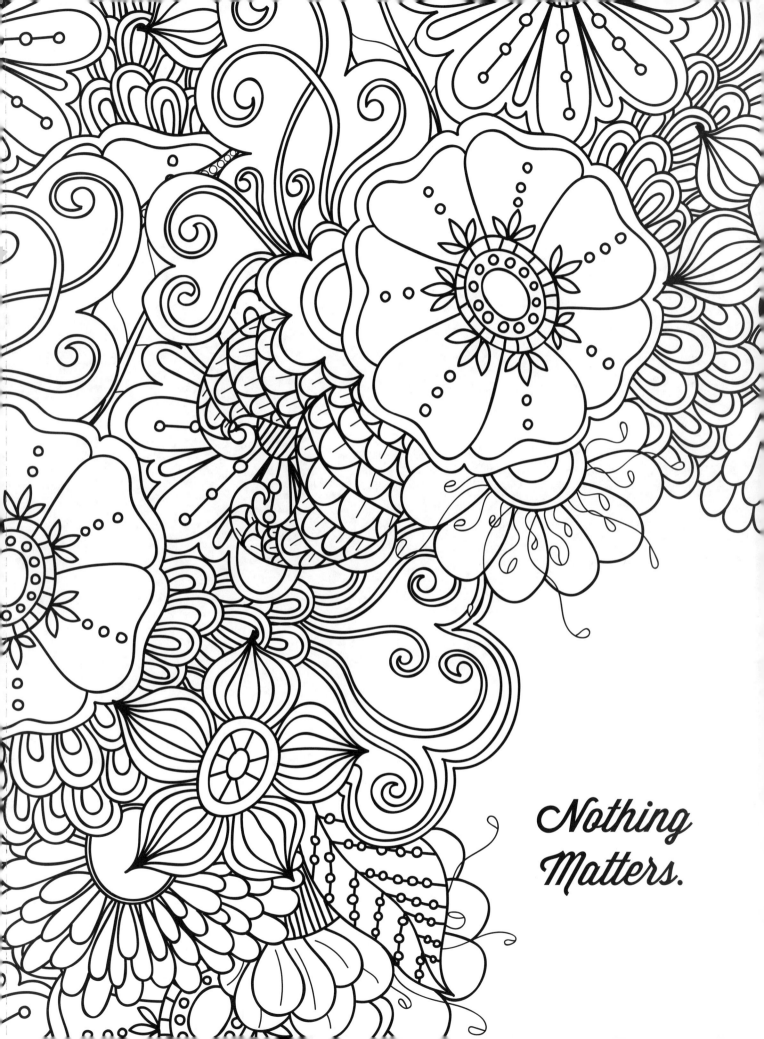

Nothing Matters.

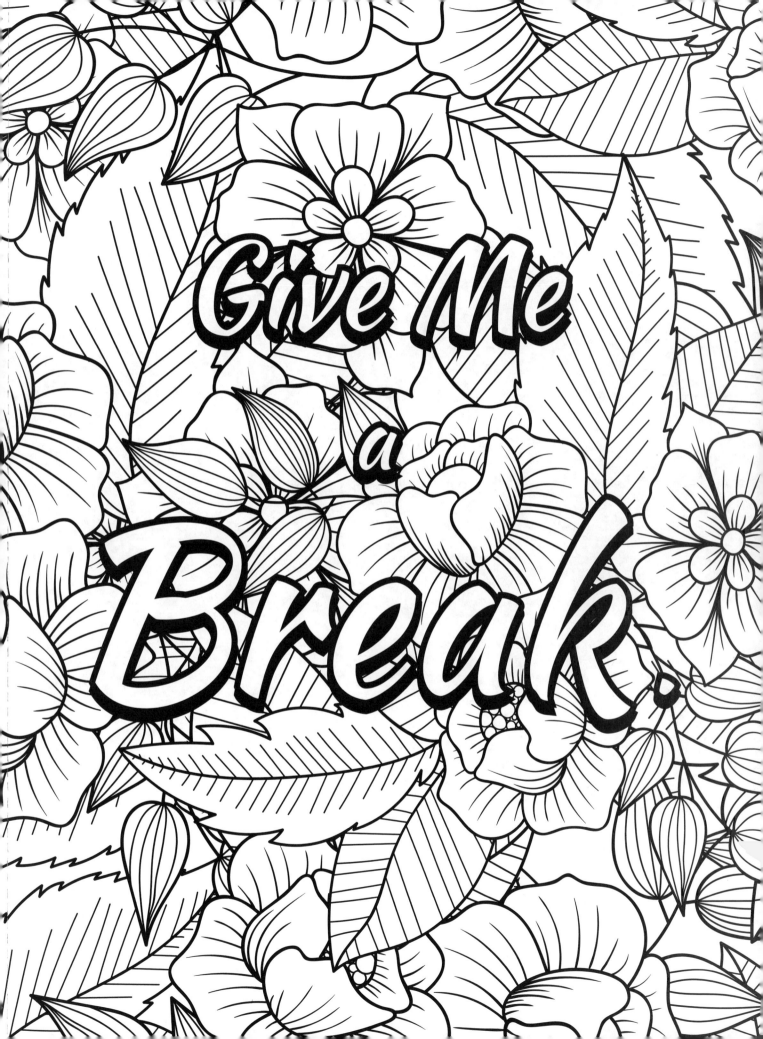

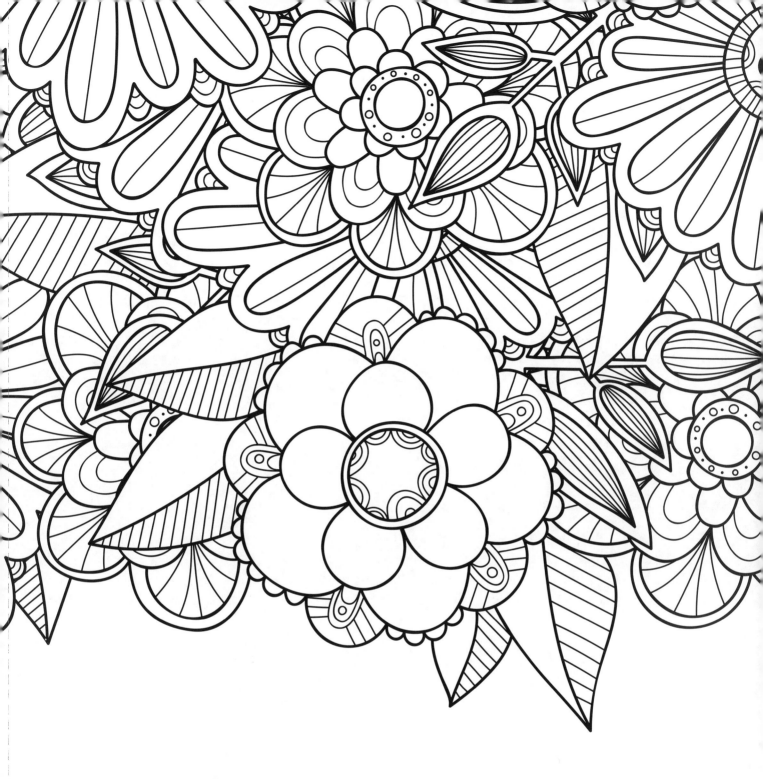

I Don't Give
a Damn.

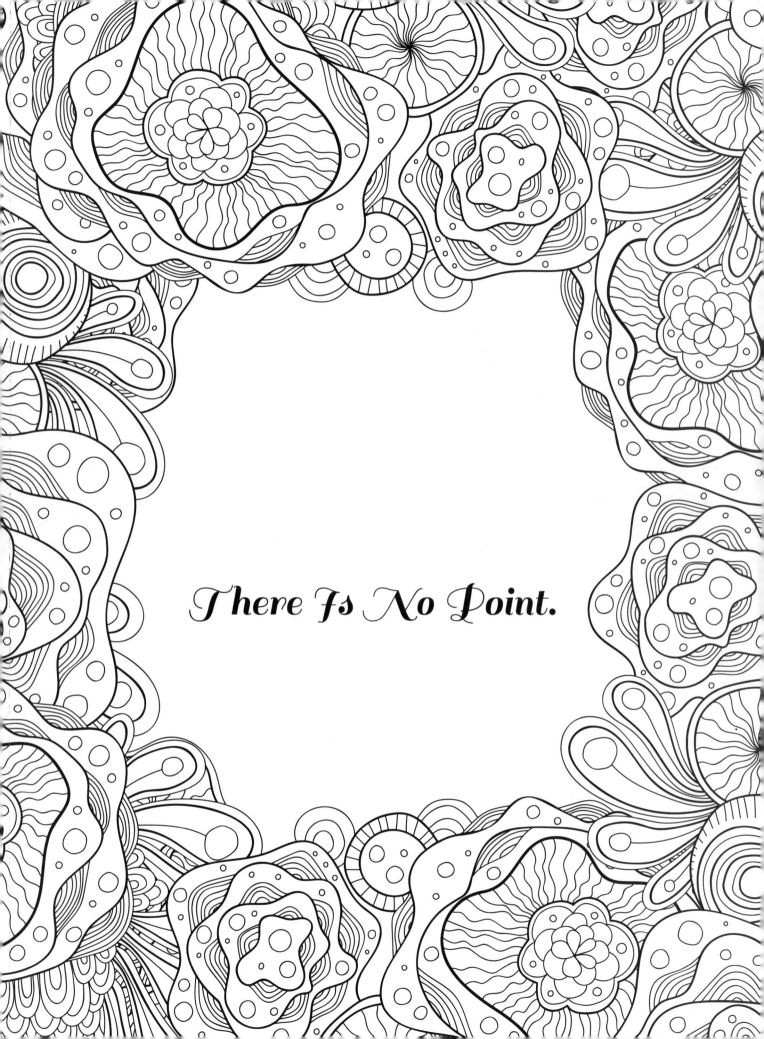

There Is No Point.

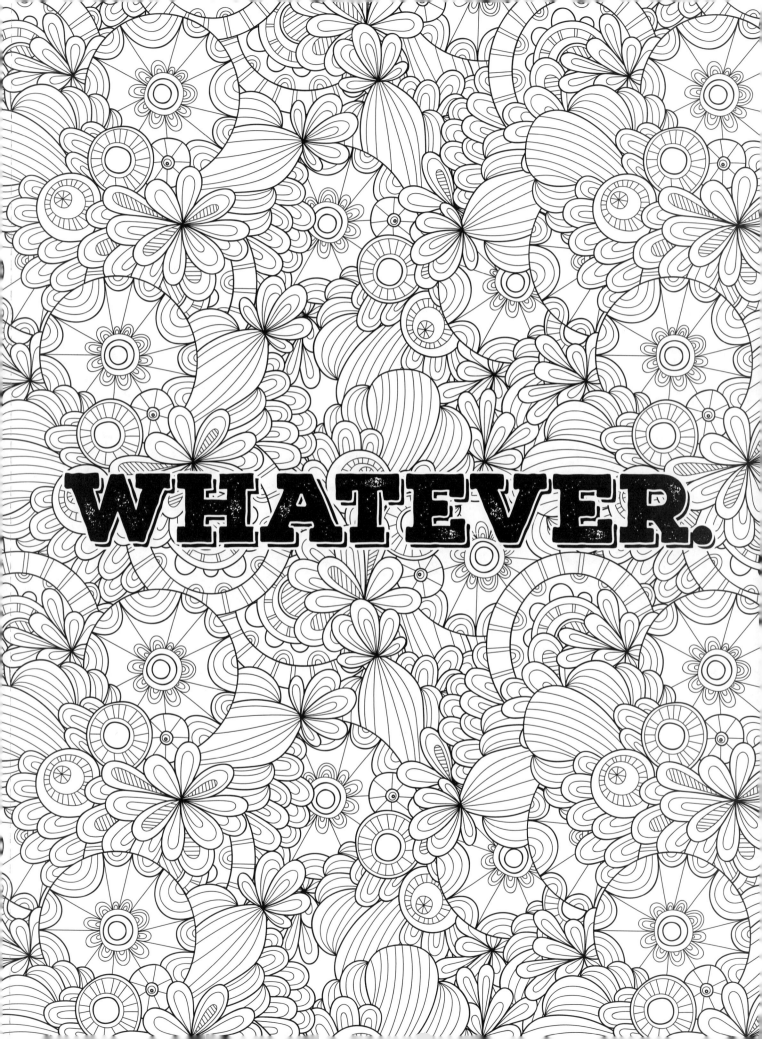

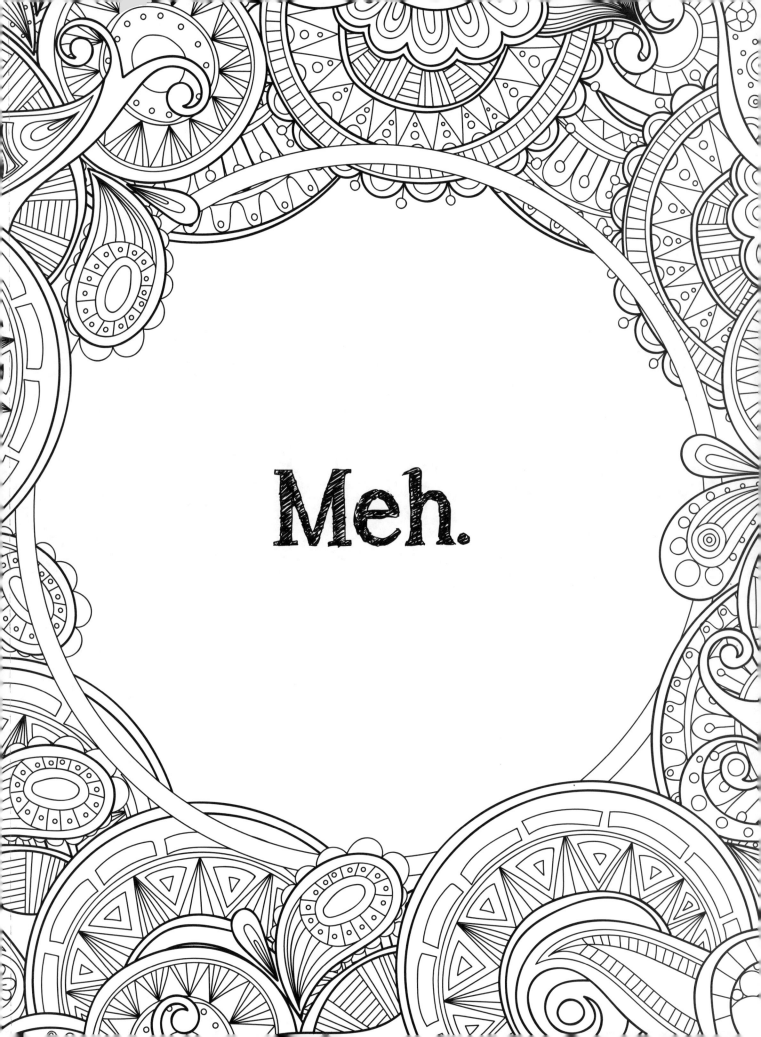

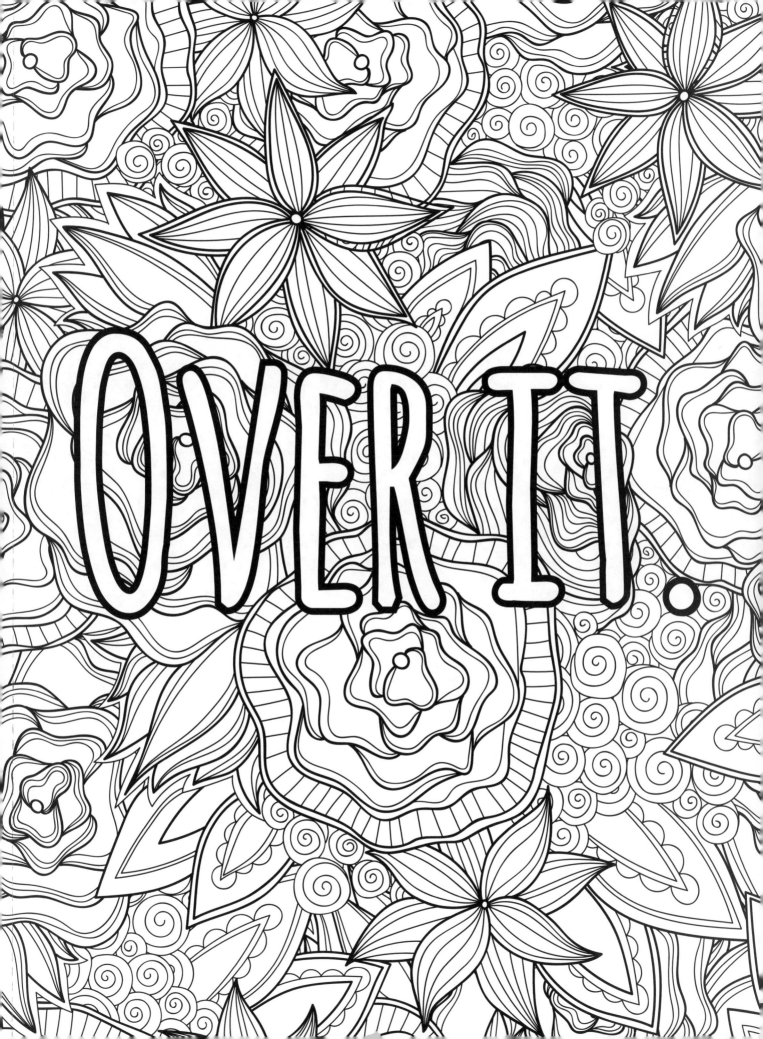

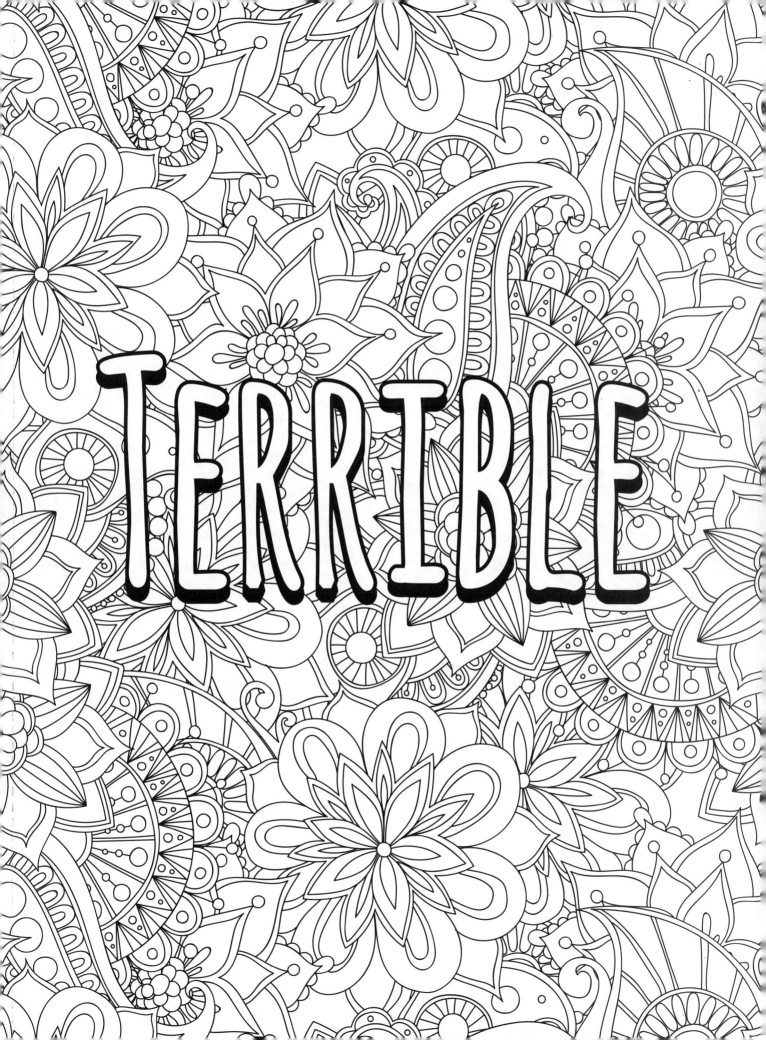

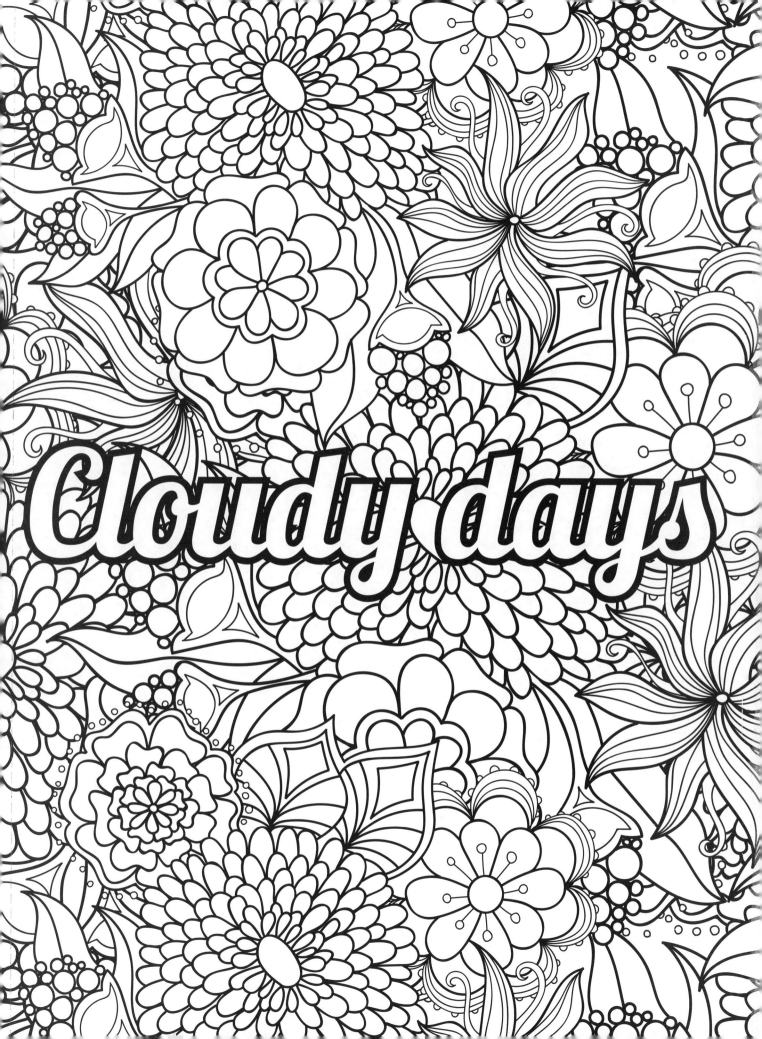

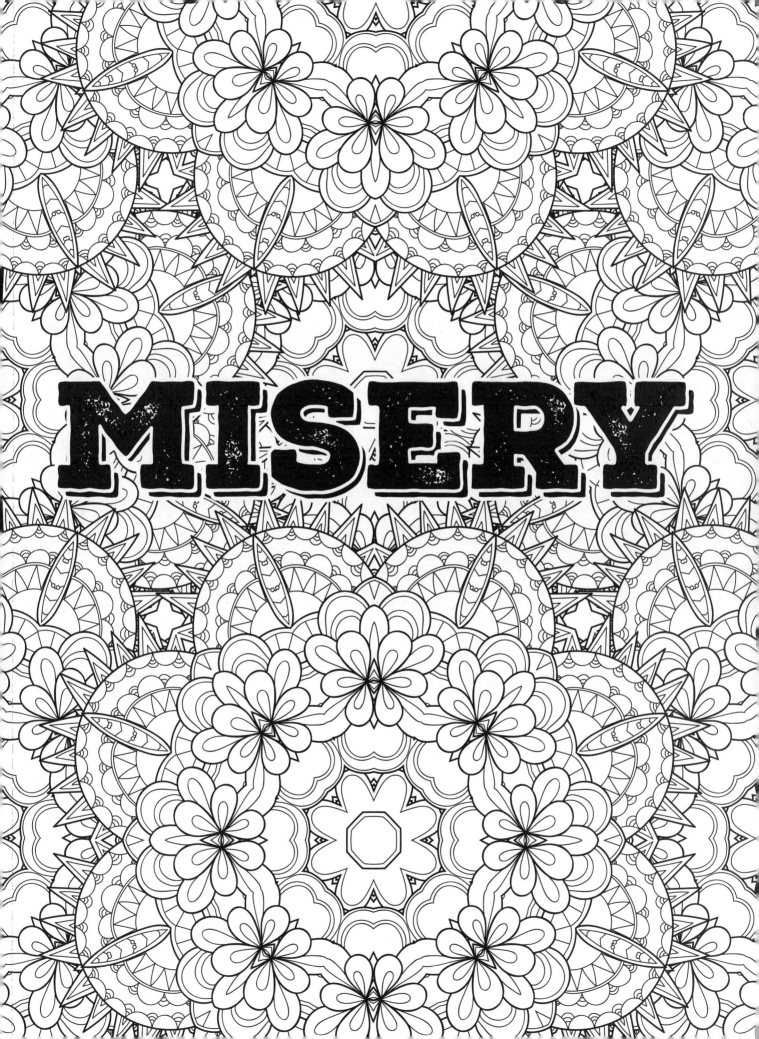

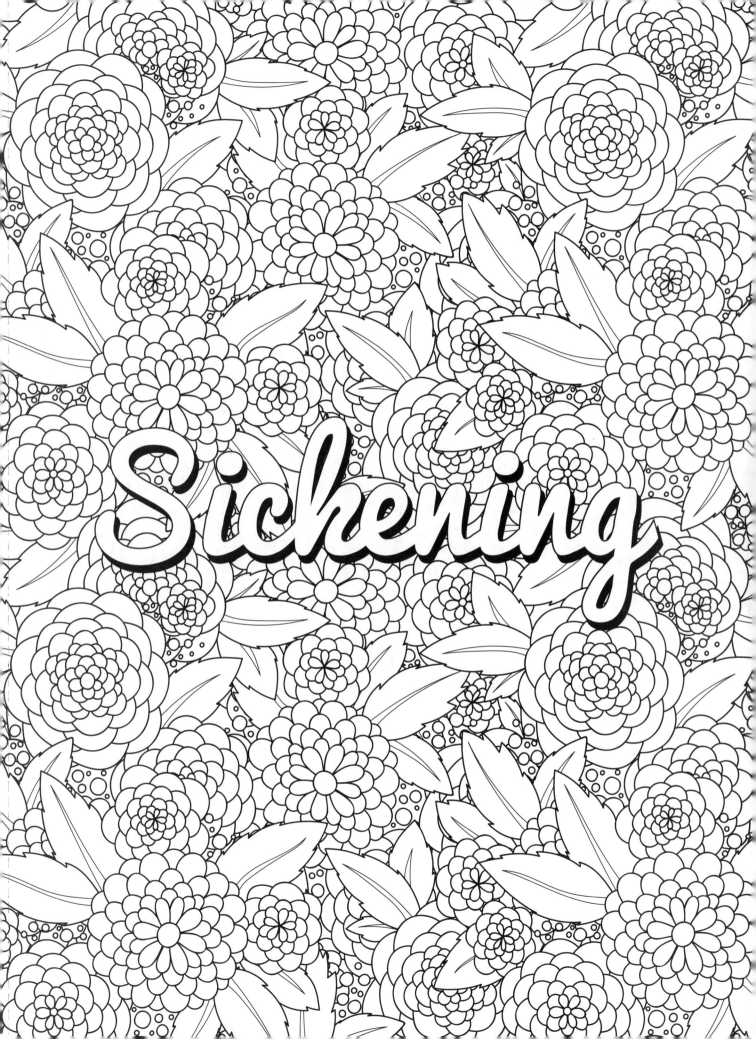

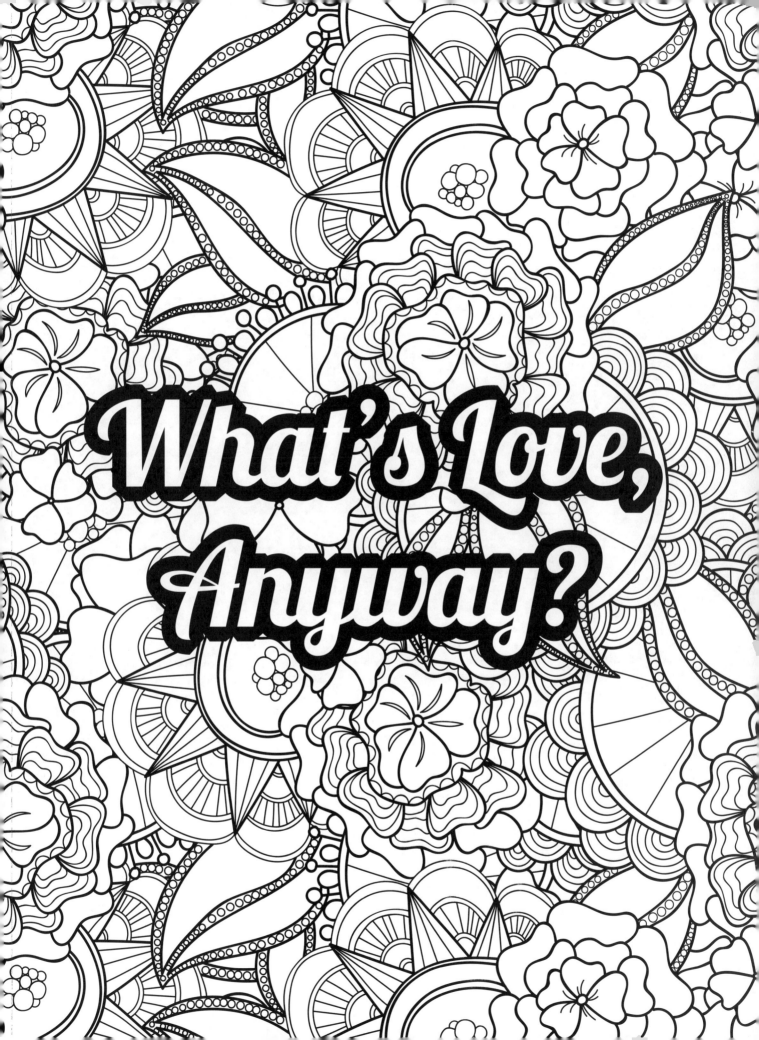

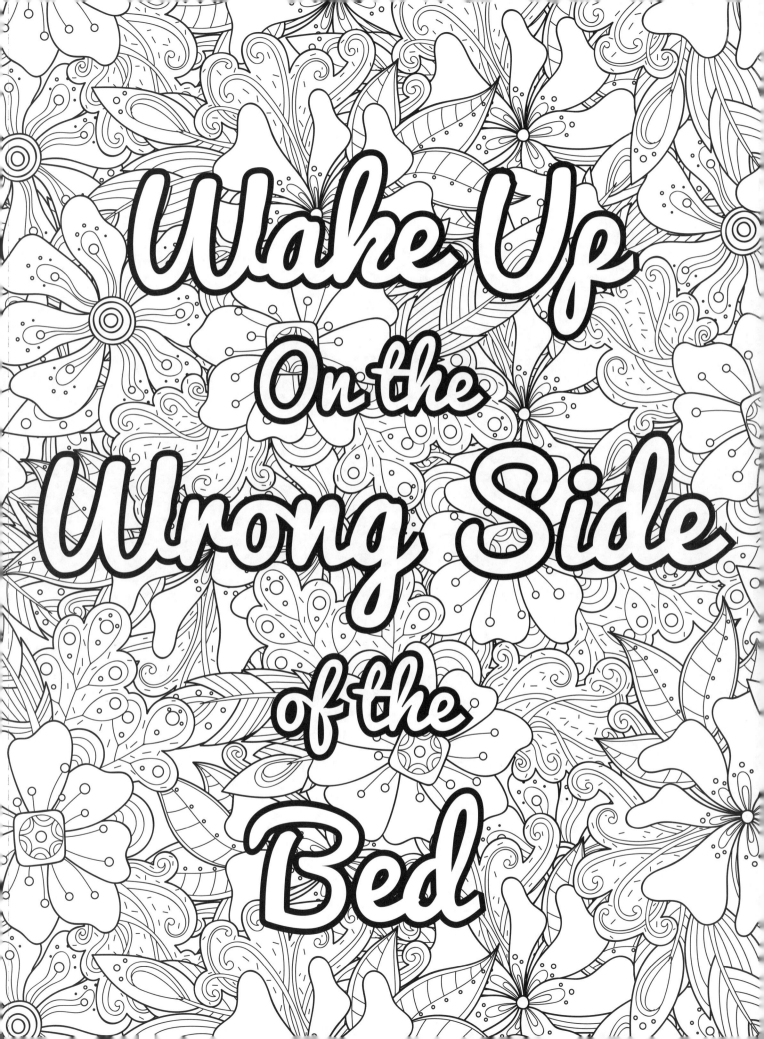

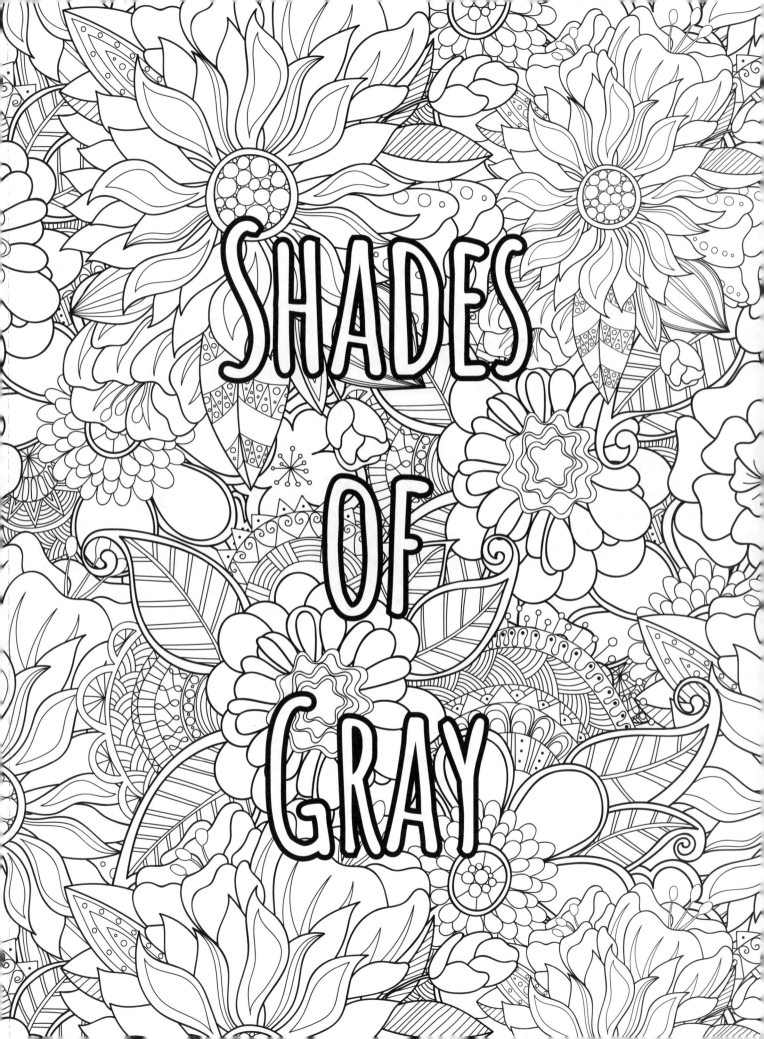

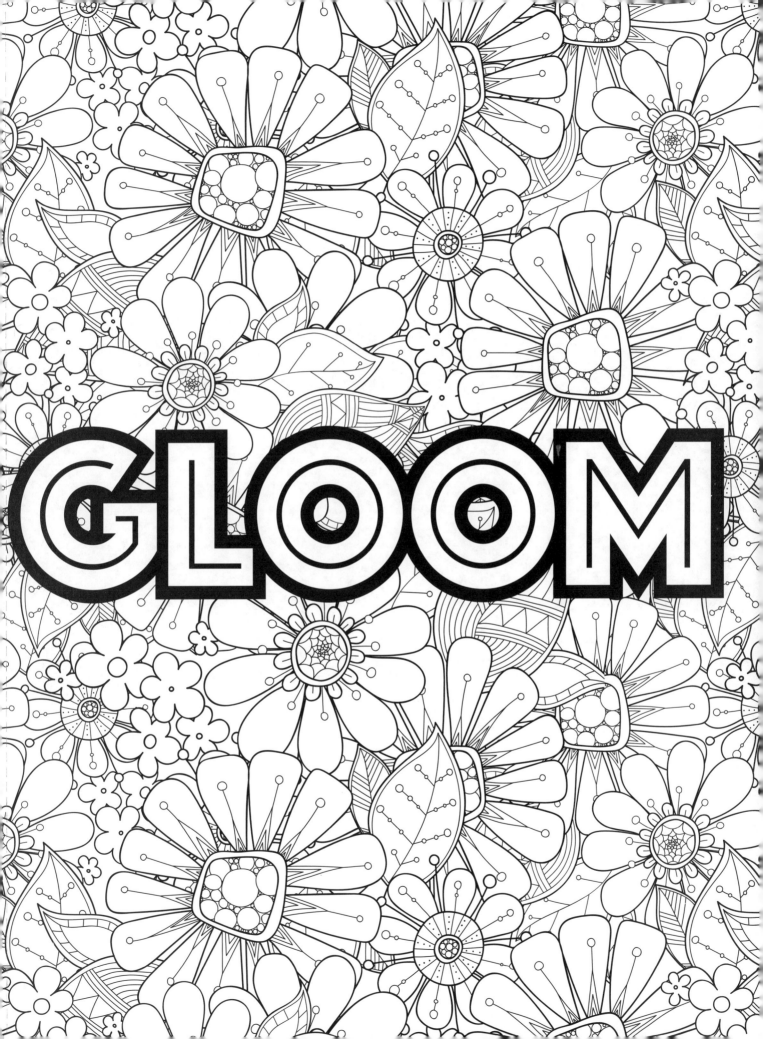

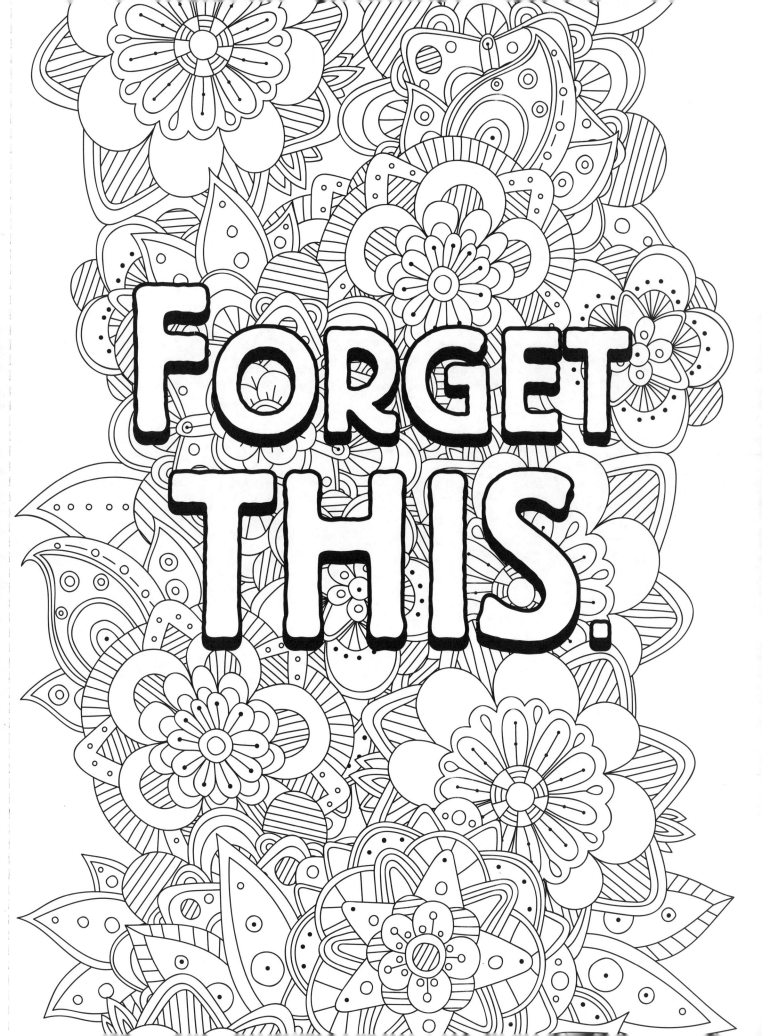